EYES WITH
WINGED THOUGHTS

· · · · · · · · · ·

POETRY & IMAGES BY
GORDON PARKS

ATRIA BOOKS

New York London Toronto Sydney

ATRIA BOOKS
1230 Avenue of the Americas
New York, NY 10020

Library of Congress Cataloging-in-Publication Data
Parks, Gordon.
 Eyes with winged thoughts / poetry and images by Gordon Parks.
 p. cm.
 I. Title.

PS3566.A73E97 2005
811'.54—dc22 2005051443

ISBN-13: 978-0-7432-7962-8
ISBN-10: 0-7432-7962-X

First Atria Books hardcover edition November 2005

10 9 8 7 6 5 4 3 2 1

ATRIA BOOKS is a trademark of Simon & Schuster, Inc.

Manufactured in Mexico

Book Design: Eric Baker

For information about special discounts for bulk purchases,
please contact Simon & Schuster Special Sales:
1-800-456-6798 or business@simonandschuster.com.

EYES WITH
WINGED THOUGHTS

CONTENTS

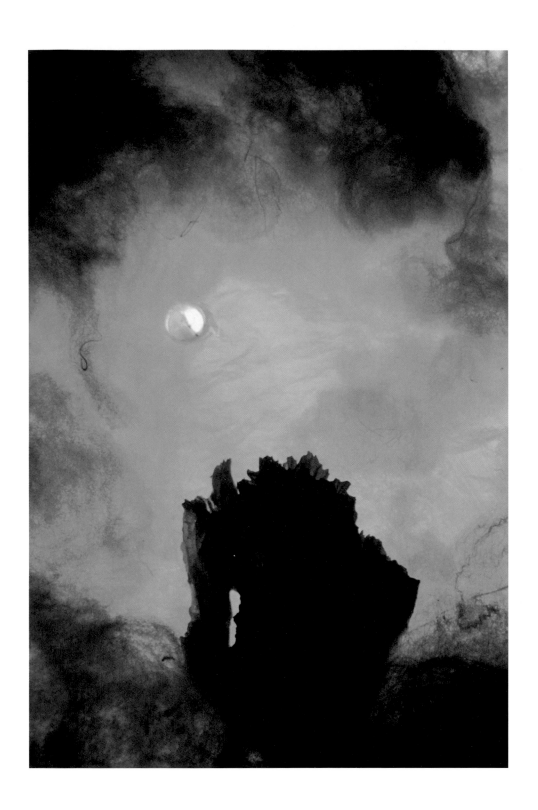

GENESIS

everything was darkness
until
He
saw
the light.
He then divided the two
with
dawn
and
there
was
twilight.

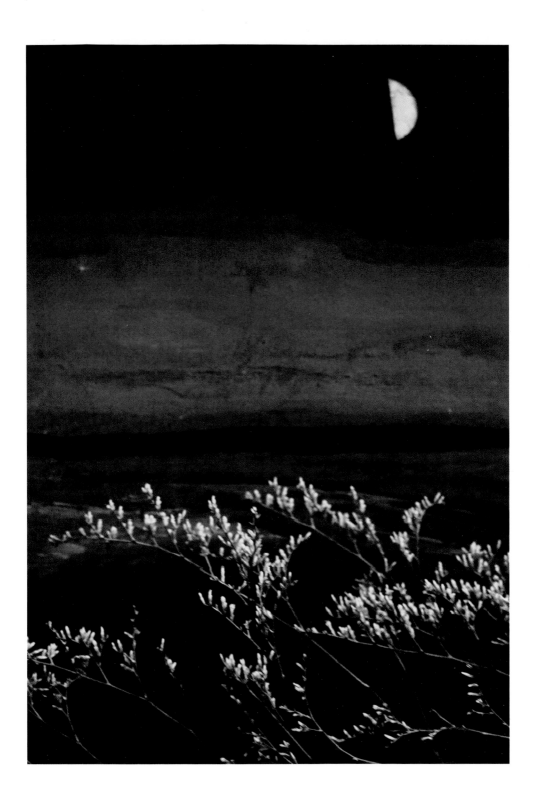

RIVERING THOUGHTS

I have several questions
for planet dwellers
who, like me, and you,
never cease to wonder
about some obvious things
that are truly not so obvious.
　　　　First off,
who's in charge
in our expanding universe?
Decisions to be made
are always on the run.

And somebody, with authority,
has to catch up with them
to make sure they're
headed in the right direction.
Somebody has to set the right hour
for dawn to appear on time
and arrange for the moon
to get out of its path.
Then there's the good earth.

Dangerously thirsty at times,
it needs to have a serious talk
with someone who gives orders,
to somebody in charge of water.

And there are those arrogant seasons
that have to fit into our existence—
vague springs, summers and winters,
all bowing to the professors of life.

With all that to be taken care of,
where hides that special someone
wise enough to call for us to die?
To frankly tell us, one by one,
I'm sorry, so terribly sorry, but
there's no more time left for dancing.

A CHOSEN SPACE

Mysterious, and so sudden,
it had emerged from the moonlit sea,
exuding a kind of icy light that offered wisdom.
Having taken shape from the water's shadows,
it cautiously came close, close—then even closer.

I became a witless innocent in its presence.
A huge silence moved in to engulf us, but I,
the devoted idiot, was totally unaware of what
my eyes were seeing. Of things washed up by the sea,
this was the strangest. For captive and countless hours,

I stood there, speechless, petrified and piously awed—
watching white wind curl up through darkness.
Providence had all but given up on me.
Then Time smiled, touched my shoulder,
and told me things I'd never heard before.

"Now and then certain wonders of the universe
descend carefully from the Maker's hands and,
 one by one,
fall into a chosen space to blot out emptiness."
Obviously, Time hadn't reckoned with those blind hours,
storms, fires and cinders that rained on my existence.

> > >

The icy illusion feeding my emptiness
beside this moonlit sea was magical.
But more wondrous was my survival.
It had to do with almost everything.

Later, in the bluest hours of my dreaming,
light fled the moon. The aberration disappeared,
leaving me with the injustice of remembering
without seeing—of touching without feeling.

Its absence attacked my slumber like a tiger,
tore the night apart with claws of steel.
The moon spit fire. Hours meant for solitude
stayed busy, burning the heavens to ashes and smoke.

Not until the green hour of dawn finally returned,
did I find this glorious aberration had also returned.

The malicious Devil had abandoned his knife and fork.
God had been staring at him with punishing eyes.
I was bewildered, but Time was smiling.
Surely I, the chosen space, would go on remembering.

AN AWAKENING

For reasons of its own
an ill-tempered sun punished the day.
Rivers belched steam.
Concrete sidewalks seemed to melt.
Birds, hiding beneath the branches,
were taking refuge from the heat.
Fatigue caught up with my legs,
and convinced my feet to take a rest.

Where was I? Who was I in this lurid inferno?

Recognizing my plight, a sympathetic bench offered respite.
It was still accommodating my misery
when the poignant moment arrived.
That moment was so weighted with curiosity,
nothing could have stopped its flow.
An aged woman was passing, lugging two bags.
Whatever signified her end was working overtime.
Sunken deeply and rigidly into herself,
her eyes lingered in the midst of wandering.
The rivers of wrinkles had flowed for many years.
A pale scalp showed through hair, ripe with whiteness.

But she was smiling!
No misleading myself. I bid the kind bench good-bye.
She had made it impossible for me to endure my suffering.

> > >

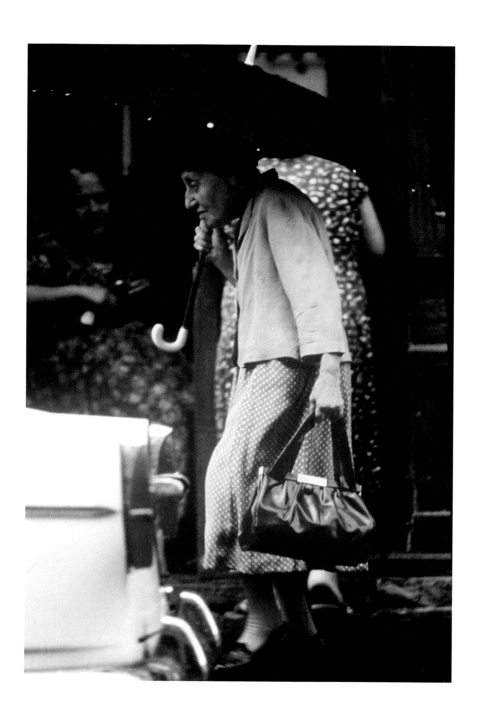

Following her was akin to crawling backward.
After a dozen steps she would stop, blow out the tiredness,
then stubbornly move forward again.
There was no street that failed to know her
nor any sidewalk that didn't expect her.
Her destination wanted no truck with a malicious sun.

When she came at last to a grimy alley,
and disappeared into its darkness, I stopped.
 The entire world stopped.

In the huge silence that followed,
the heavens opened.
Rain came plummeting down!
Bolts of coolness rushed in!
Schools of joyful birds took flight!
Suddenly I felt my legs, smiling.
My feet hurried toward home.
The sun had given up—withdrawn its anger.
The courageous lady had conquered its wrath.
And no sweeter time has touched my universe.

I can't stop wondering about that smile she wore.
It was still there when the darkness swallowed her—
 Still dreaming, still full of secrets.
Obviously it had been her friend for a long time.

One thing for sure. Nothing will erase her smile from my memory.

MOMMA

Now and then she said things that made my ears frown.
More than likely they were just too young to understand.
"Brush those teeth, and wash your feet before you go to bed.
And stop snoring so loud. You keep everybody awake."

Pig feet, turnip greens and chitlins put hair on the chest.
My stomach craved apple butter and crackling bread.
It had a mind of its own. It wasn't looking for hair.
Sunday school was particularly necessary, but not enough.
Reverend Frockcoat's bland sermons had to sanctify the day.

Some other things stood in my way—
talking too much when I should have listened,
crying when laughing was better,
shooting marbles when the cattle needed feed.

Momma's most relentless warning stuck like claws.
"Son, don't ever come home blaming your skin's blackness
 for tumbling you downward.
If a white boy can do something worth doing,
remember, you can do it too. When the time comes
just get out there and do it—or forget to come home."

Much later, long after she was gone,
and swimming in her advice, I've tried to keep going,
 going and going.

Down through the years, her warnings helped push clouds away—
while sopping tears from stars that insisted on falling.
Yes, it was Momma who spread the checkered tablecloth.
But it was my good fortune to sit down and eat.

Her love filled the space between heaven and hell.
She was a mother beyond all other mothers.
 I owe her everything—
my breath in the half-light of autumn,
for spreading patience when doubt surfaced,
for smiling at the unrest that overtook my anxious feet,
for guidance that walked me away from mistakes,
and for hands that pulled me out of the storms.

Yes, I owe her for these things—and many many more.
So no good-byes, Momma. The love petals
falling like rain upon your grave
 are mine—all mine.

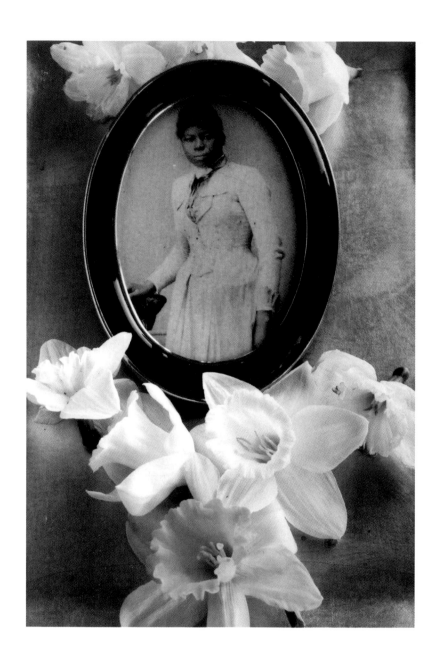

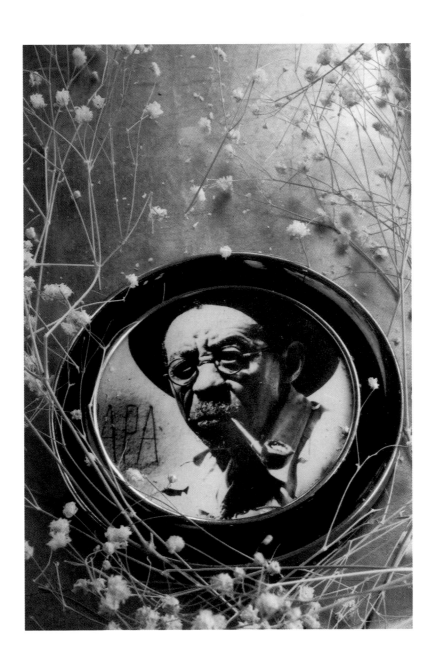

THE PARTING

Two roads passed my father's house,
paved with roses and thorns.
They went everywhere, with tolls
unfixed on unmarked distances,
paved with roses and thorns.
Papa said a few things when I was packed to go:
The feel of your feet will reconcile the differences
 in which road you take.
Signposts along the way will give devious directions.
It is your right to question, but don't ignore them.
 Each one is meant for something.
Summer grass underfoot will be kinder than weeds.
Yet during winter storms, it will be the taller stalks,
leaning above the snow, that will catch your eye.
And you will learn that all things are not the same.
You must select your friends with the same care
 I gave to selecting your mother.
Avoid things that die too easy, and get your soul ready
 to die well.
As you grow older, you will pray more and worry less.

Well, what I've told you might amount to everything,
 or maybe nothing.
Just be thankful if, in autumn, you can still manage a smile.

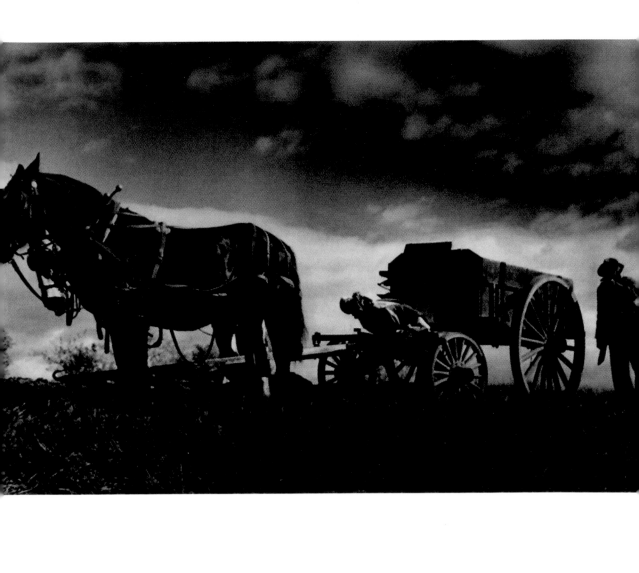

DEATH OF A WHEAT FIELD

While my father swilled the hogs
and hayed, they became my friends.
Slipping through my fingers like watersand
into the grainy deep of the oak bucket,
gushing from my hands' leather bowls.
I ignored Papa's gruff command,

"Let those seeds be, boy. Let them be."
Then to the rumpled field he went one day,
 angry.
Scattering my friends, burying them underfoot.
 I saw him with my own eyes,
throwing them to the unfriendly wind.

With a sorry heart I watched them die.
Thousands of them, my friends, while
my father swilled and hayed.
But one morning in the sprouting spring
while he toiled at other barnyard chores,
hundreds, then thousands, then millions of them
peeped up, slender from their graves.

Smiling, tender green-pointed smiles,
 my friends were alive again.
And from the rain they drank, from the sun they fed—
Growing a busy carpet-field for naked feet to play.
Three, four, five feet tall they grew while
my father wasn't watching.
Then one dawn he caught them swaying there,
laughing at him in the spring wind.
To the toolshed he went and honed his
 wicked scythe.
Out then to murder them right before my eyes.

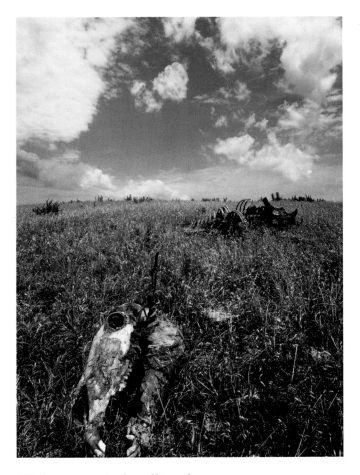

Without words, bundling them,
whacking off their heads,
leaving their thin bones for suns to burn.

A fitting funeral I had for them—
Pyre-stacked for sacred rites
 beneath the pagan fire.
And God sent mosquitoes by the billions for a
 choir.

I heard them with my own ears—
As my father swilled and hayed.

THE FUNERAL

After many snows I was home again.
Time had whittled down to mere hills
the great mountains of my childhood.
Raging rivers I once swam, trickled now
 like gentle streams.

And the wide road curving on to China, or
 Kansas City, or perhaps Calcutta,
had withered to a crooked path of dust,
ending abruptly at the county burying ground.
 Only the giant who was my father
 remained the same.

A hundred strong men strained beneath his coffin
 when they bore him to his grave.

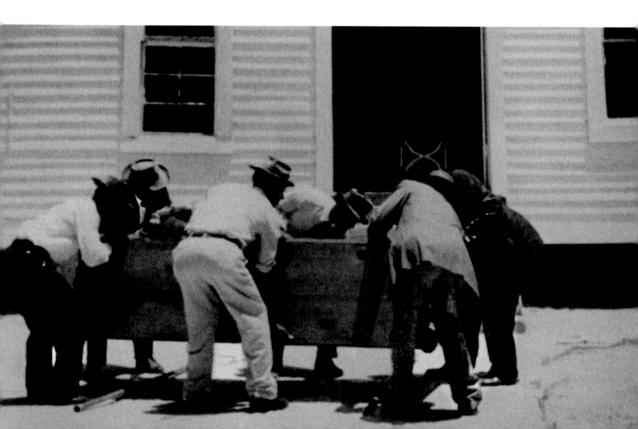

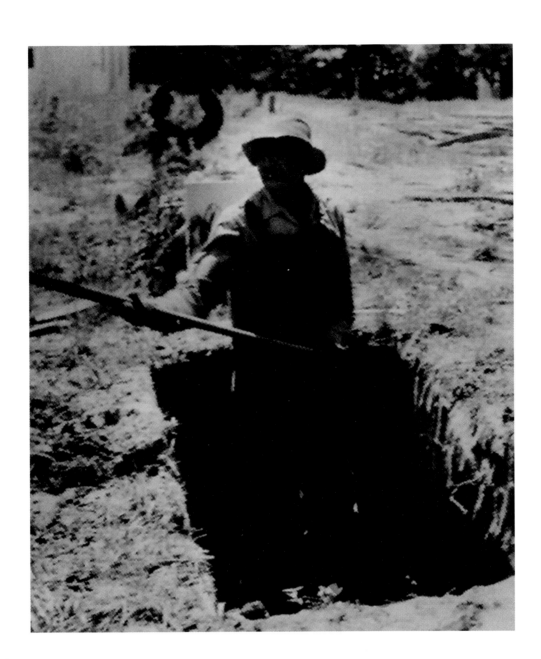

THE MOTHER'S LANE

I always walked with me when I walked with my Momma—
through that green, hallowed pathway near home.
And even the trees bent over to listen to her words,
honed with steel and laced with amaranth.
Her words fell on my ears like ripened fruit,

 to travel beside me,

 to soften the rocky paths,

 to shield against weapons

 that seek to pierce one's soul.

No, Momma's words refuse to die.
Instead, they grow wings and soar.
And their constant echo bleeds me dry.

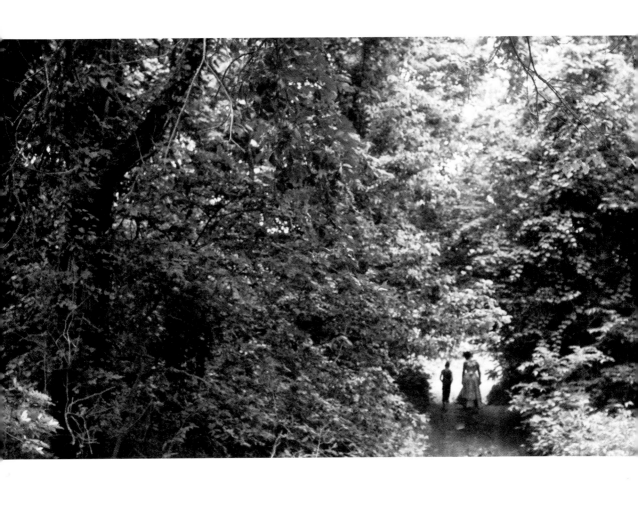

THE FINAL HOURS

Those years providence granted her,
burned into a pile of dreamless ashes,
left over from a ruffled and icy past.
Here now in this wrinkled place,
where her life had decided to stop,
she was finally handing herself to heaven.

Wars her heart had fought were over.
And only a few glasses of cloudy wine
would be lifted to mourn her absence.
Many, whose hands she held, were gone.
Sleeping, beneath grasslands on the other side,
 they awaited her arrival.

Looking ahead, the pastor had consulted his Bible.
The old coffin maker was shaping the burial wood,
the grouchy stonecutter was sharpening his tools.
Floating on heaven's edge, the angels waited.

But Satan, pouting somewhere in a black corner of Hell,
 sat, splattered with ill fortune.
Love and religion, Heaven's two most potent weapons,
had crushed the chance of enlarging his domain.
All people, be they Black, White, Purple or Red,
were more than welcome into his fraternity.
But
 sinking
 to
 his
 level
called on ruthless hearts with inexhaustible needs of pain.

BELINDA'S TEAR

With a mother gone the world stopped.
Nothing was left to quell the anguish.
Naturally, and ever so quickly,
pain leapt from her heart to her eyes,
then swept downward to her cheeks.
Locked now into her youthful bones,
anguish dripped into a mournful tear—
one with the shape of gnarled sorrow—
one that refused to die with night or dawn.
No, the matriarchal flame would not desert her.
Having declared the depth of her loneliness,
its presence was still there, and not to be forgotten.
And as for that silent tear, it will flow on and on.

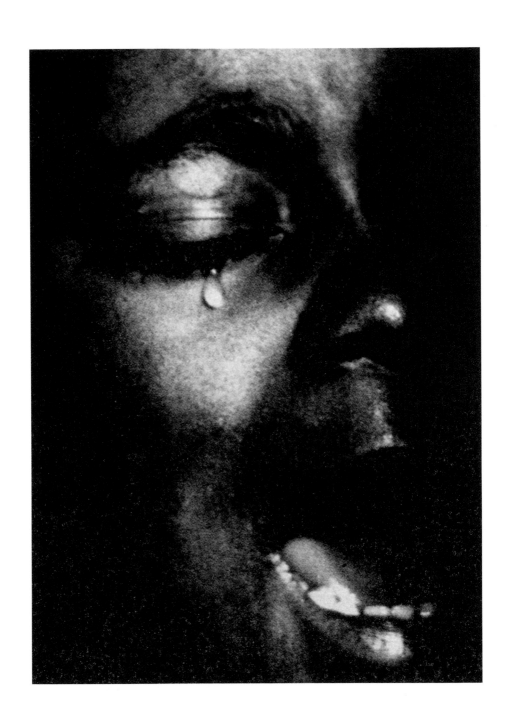

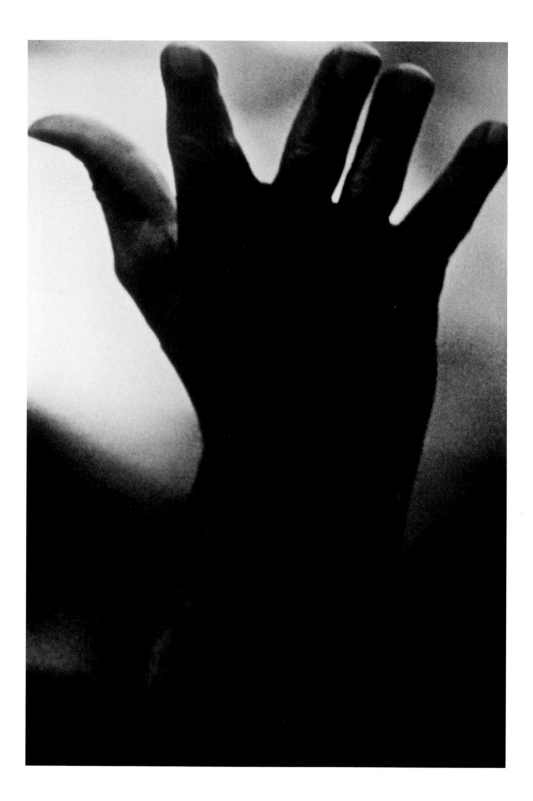

LAST RITES

". . . And if you're around when I have to meet my day,
I don't want a long funeral. And if you get somebody to
deliver the eulogy, tell him not to talk too long. I'd like
somebody to mention that day that Martin Luther King Jr.
 tried to love somebody . . ."

Razored and eloquent, Martin's taped plea flowed above his
coffin, into the rafters of Atlanta's Ebenezer Baptist church.
Veiled in grief, his widow's arms embraced their children.
And as the white-robed choir sang hymns from his
childhood, that voice rolled on over heaven and earth.
"I want you to be able to say that day that I did try to feed
the hungry, that I tried to love and serve all humanity . . ."
For all this a White man blasted a bullet through his neck.

Surely he had filled Black people with a sense of hope.
But at this despairing moment hope seemed shattered.
 That bullet found its mark.
In death Martin let us know who we were, what we are,
and that we were still in a land of oppression and assassins.

Violence and arson in big city ghettos darkened the sky.
The Black man's only answer to a White racist deed—
 "Blood and fire! Fire and blood!"
Despite death, King's solemn voice endured.
 "I'm tired of shootings!
 I'm tired of clubs!
 I'm tired of killing!
 I'm tired of war!
No violence no matter who says so!"

His words
to the militant appeared weak, worn and waxen.

> > >

Thirty people died that week. They were mostly Black.
 That White man's bullet
nearly eliminated the peace between us.

We struggled to separate his foul act from your conscience.
You may ask, Are all Whites to be blamed for what one did?
You have a right to know how Black people really felt
before grass took root over Martin's final sleeping place.
Dreaming no longer devoured us. We were angry! Angry!
We had been brutally pushed to the edge of the precipice.
It was impossible to control what lay deep inside our hearts.
All the looting, burning and killing made matters worse.
But a question for you. How else could ghetto dwellers have
expressed their futility?
Should they have called White cops, who so often gave them
the back of their hands and the end of their billy clubs?
Do they call the Mayor—or the White House?

The mourners were wondering.
Perhaps reacting out of fury,
their hearts demanded answers.
Where was the killer? If caught, what would be done with him?
The hopeful songs of their fathers lay smothered in doubt.
The patience of awaiting God's deliverance vanished.
Faded, His promises were being taken out of time.
Demanding a share in the affluence that surrounded them,
young Blacks crossed lines even though it meant death.
The voice that flowed through Ebenezer ran through them.
Conquer the fear of death! Otherwise you are lost already!

His worship of that belief got him jailed, stoned and stabbed,
carried him into water hoses, dogs and angry police clubs.
 His only armor was truth and love.
Now that he lay murdered, one wondered if love was enough.

Racist flags still waved. Blacks and Whites were buying guns.
Army troops stood waiting. Ghetto fires kept burning . . .
The President had been warned, "Don't go to Atlanta."
Martin's dream had suddenly burst into a nightmare.

No handsome limousine bore him toward his final bed.
Two proud mules and a farmer's wagon did that.
With thousands walking behind him he rode in peace.
 Now try to believe what I'm telling you.
Casually watching the procession from the wood-side
was a White cracker, paying his respects in his own way.

The juice from a slice of watermelon he devoured
dripped down over the bib of his overalls.
It was saying just about all that he wanted it to say—
I could care less about the color of your savior's death.

But suddenly his eyes bulged with confusion.
In that sea of blackness where grief was howling,
White faces also swam in Martin's final journey.
 Hope was spreading.
The deserted space that surrounded hope waited
for hatred and unrest to lock arms,
enter the flames and burn together.
Then, and only then, could the world begin to rejoice
for Martin's hopeful kind of poetry.
 He had a dream—
of Blacks and Whites coming together like souls touching,
without holding fear or hatred for one another.
Love! Love! should be our inexhaustible companion.

That dream still endures through most stations of the wind.

A SOULFUL WEAPON

A better day is coming—some say.
Common sense challenges the future.
Even Satan should consider bowing out and offer promises
to those arriving tomorrow.
Hope and love is what they long for.
Keeping faith in one will bolster the other. Existence without either
is living without bones.

Incredible! Zealots still spit out vicious names—
"Nigger!" "Kike!" "Spic!" "Wop!"
Even now, such hostilities seem glued to extremist lips.
Well, let's face it. Racists keep hanging on, screaming about everything,
but they ain't saying nothing.
We have to learn to reject their poisoned tongues—to ruthlessly destroy them—
like cats do rats.
One's soul is the most powerful weapon against zealots.
You can point to the soul's victories again and again.

What to do?
It's simple. Keep acting and thinking upward.
After you've thought aplenty and done aplenty, just shake your head and smile,
then put your soul to work again.

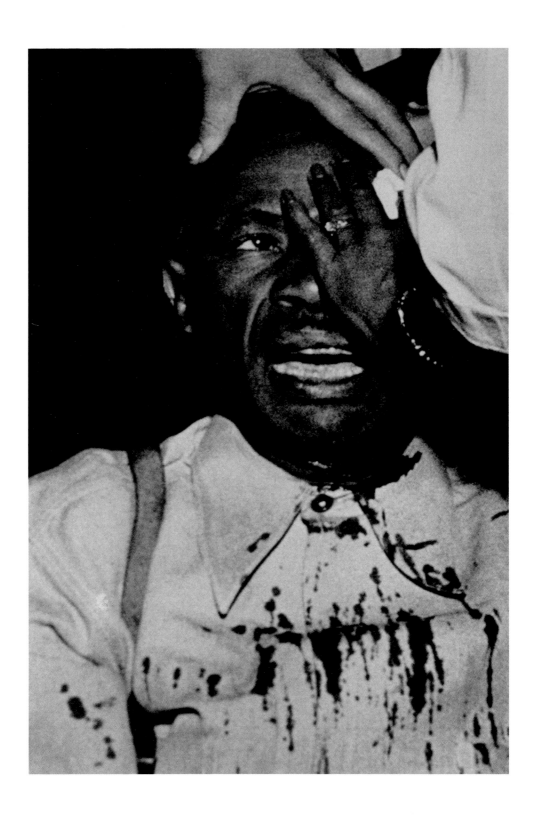

UNCLE JED

Like Papa, he was a brave fisherman.
When the time came to mourn him, I suffered.
He was superb, that uncle of mine.
I loved the smile he wore on his rugged face,
and nothing put it there quicker
than the splash of his skiff into the sea.

And the more rugged the waves, the better.
He's gone now, resting peacefully, I hope,
in the arms of his murderous friend—that sea.
But through the window of my memories

I still see him, tossing a net toward the sun,
watching those trapped silvery codfish—
leaping hysterically against captivity.

I tell you all this because
there's no one else to tell;
no trees were there to watch.
Uncle Jed is dead, long dead,
but his final moments roam my memory.

We were plowing waves when the sky darkened.
He was, as usual, puffing on his cob pipe
and questioning God's ways of handling things.
Yesterday's needless sorrows, stinging nettles
were under discussion when thunder rumbled in!
Lightning flashed! Cantabile moments screamed!
Chaos reigned—and snatched Jed into the angry sea.
 Then, at this bewildering moment,
a despotic power refused to grant him life.

So take a walk with me through my memory.
Show me why that power destroyed him,
bemedaled him with death.
You might say

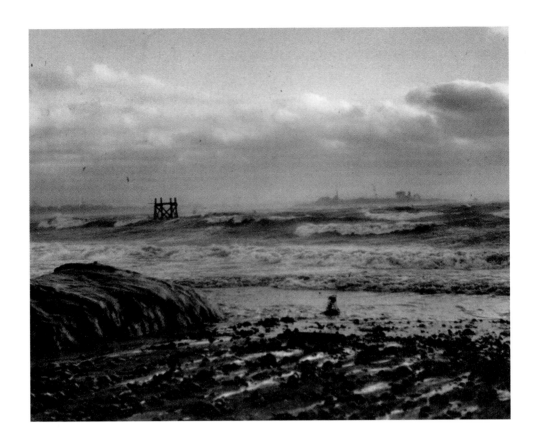

that those silvery ones that escaped Jed's net
would prefer to see his name engraved,
by their fins, upon his tombstone.

Don't deny the codfish thoughts or existence.
They seek peace inside the naked waves.
Yet they have one thing to be thankful for:
Uncle Jed's nets lie safely at the bottom of the sea.

But they must swim cautiously in the water-shade.
In the full light of each day—other nets are waiting.
Come, take a walk with my memory
through that miserable morning,
then, if you can, appease my misery.

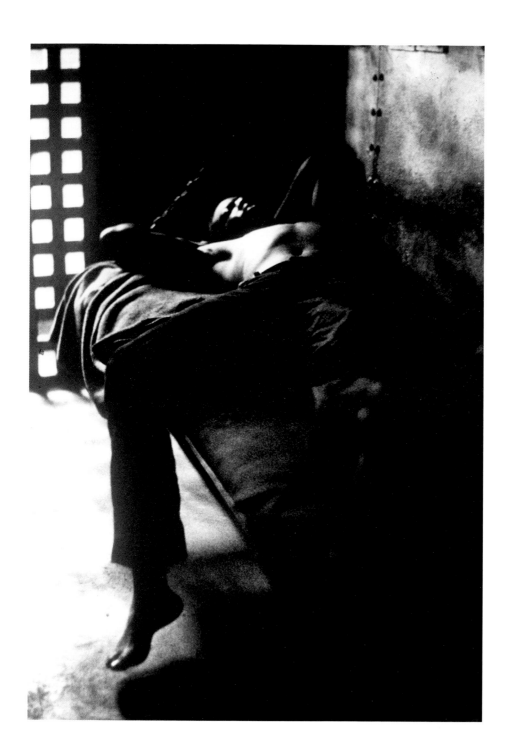

LOOKING BACK

So easy it is to remember my starting place.
A glance at the crib takes care of that.
It's those distances in between
that call for close watching.
How long is a mile, if at one time or another
I made the wrong turn and lost my way,
just for one day, or perhaps an hour?

Caught up in the problem, I visited my past.
I did some things some said were wrong,
while others told me honestly I was dead right.
Before long I was stuck between Heaven and Hell.
There were those who frowned at my intentions,
while others applauded every uncertain step I took.
Yet not a single one explained what my problems were.
With my thoughts turned upside down, I visited a preacher.
He invited me to prayer meetings, filled his pockets
with my weekly earnings, then promised me Salvation.

Uncle Charlie was downing a cup of gin when I called on him.
His advice startled me. "Don't grow old all by yourself.
Find a good woman. Share your best pillow with her,
then work hard at keeping her smiling and contented."

Well, at last I've stopped worrying about such things.
Forgetting all my shortcomings leaves me much happier!

A PIECE OF HOPE

For Pedro, Lucinda's exit was too sudden,
 and much too early.
Dawn made that clear with a bucket of tears.
 And, like a wounded tree after a violent storm,
the morning offered a few broken limbs, without
 leaves, fruit—or his woman.
Her flaming threat, stoked with hostile warning,
had left their bed tortured and hopelessly burnt.

Her daybreak departure left no regrets.
Remorse had suddenly flown to nowhere,
leaving him to share company with her absence,
to suffer again the blowing of a treacherous wind.
Riding now in loneliness, he talked to his horse's ears
 burying himself
 deeper
 deeper
 and deeper.
The love-bed had caught fire!

> > >

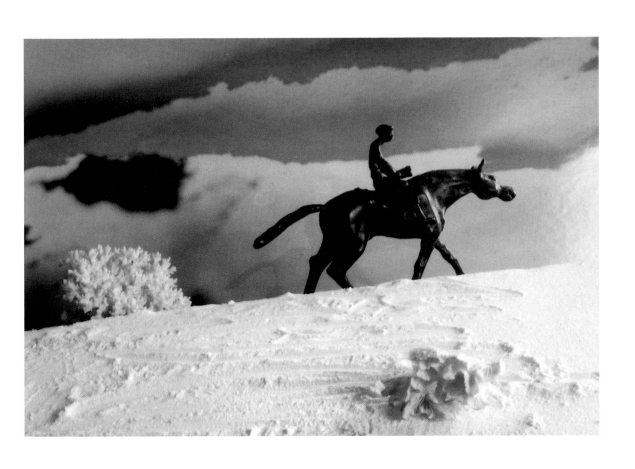

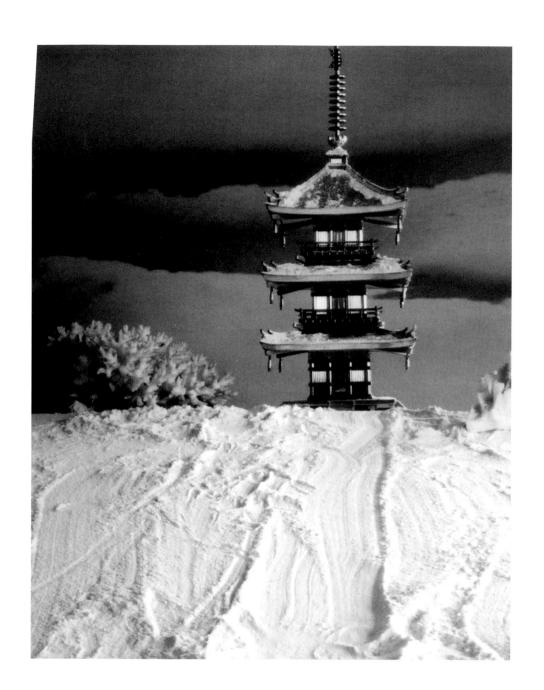

Truth, after frowning at all of Pedro's excuses,
had nobly distinguished itself!
And, without doubt, proclaimed,
Pedro Hawkins was indeed the sole arsonist!

Traveling like someone underground,
everything was terribly dark to Pedro,
even the snow. But his soul listened to his heart.

And this is where his soul chose to remain,
living in the middle of his finest memories of her,
just outside the borders of his fondest dreams.

There, and there only, can his soul bask in silence.
His thoughts, cruising some blest future, cry out—
There, my woman and I will find an inexhaustible love.
Well, perhaps, Pedro—perhaps. But, at least to me, it seems
your passions will find it hard to come together.
Let's face it! Pedro's doubts could overflow the universe!
And his mind is as changeable as the wind.

Could be, that somewhere in the years ahead,
a pagoda filled with Pedro's golden dreams is waiting,
silently waiting—to greet another dawn without fire.

BIRDS

When snow starts falling,
the rich wing off for Southlands.
 So do birds.
But for them circumstances fly far apart.
Imagine, if you can, an angry blue jay
berating a frustrated palm tree
for not having a secluded suite available,
or a slew of soft leaves for a newborn's bed.

Imagine, as well, the blackbird's supper
after its perilous cross-country journey.
(No succulent steak, salad or exquisite wine,
instead, raw June bugs, roaches and skinny mosquitoes.)
When the hue of turtle soup covers the sky,
 birds sleep.

Twiddle twaddle, we're apt to say.
But until we've worn a pair of wings
that allows escape from frowning places,
we'll have to bow to our imaginations.
Strange, we take birds for granted—
never understanding what they say,
 know or feel.

Yet, like us, they move instinctively
to the mysterious workings of time.
Be you a bird, pig, snake or king—
 oblivion is our final landing.

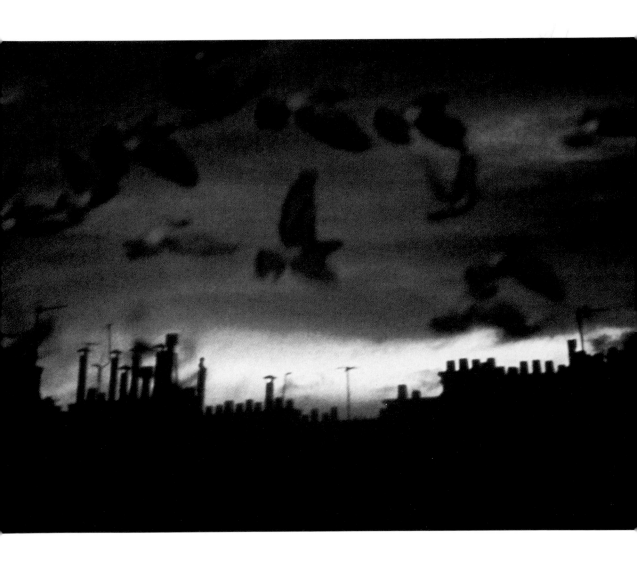

A WINTER TREE

The indifferent mountains were clothed in silence.
Death, it seemed, had taken care of business
and murdered all in the cover of blackness.
Now, weighted down with December's white coat,
the arrogant winter tree stood radiantly, smiling
above the corpses of yesterday's exultant spring—
a multitude of golden leaves and exotic flowers.

Having served their time, seeds now slept peacefully,
beneath frigid branches with disgruntled roots.
The winter tree had good reason to smile,
the crevices granted by time and circumstance
also granted it respite until another spring.

So, during the whitened months of autumn and winter,
wastelands for burial might rightfully be set aside—
 for spring's temporary absence.

A smart future looks to the past.
With ages of experience, winter trees tell us that.
And the foliage of returning spring always confirms it.

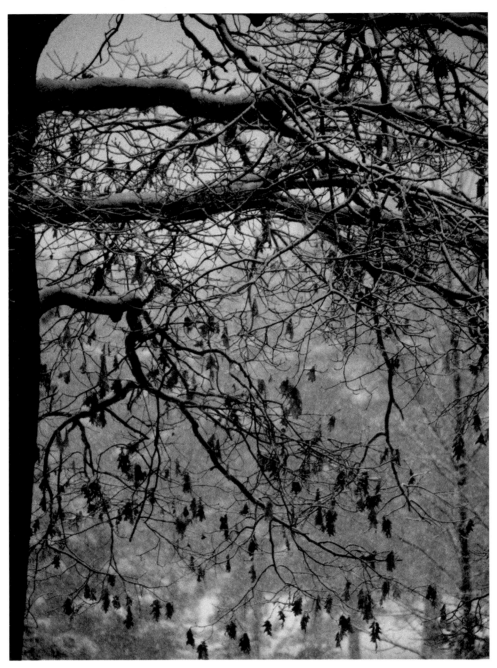

© Johanna Fiore

A CELESTIAL STORK

After centuries of wandering
a stork emerged from the lofty darkness
to take a walk among the clouds.
Dressed in the color of blackened snow,
its plumage lent extravagance
to the gray morning of flame and smoke.

Far below, humanity is unaware
of the winged silence, floating overhead,
gathering in moments of ugly wisdom.
On and on it flew above the human chaos,
its feathers taking colors of earthly hues.
Soaring through earth's troubled winds,
it witnessed life perched on cliffs of disaster.

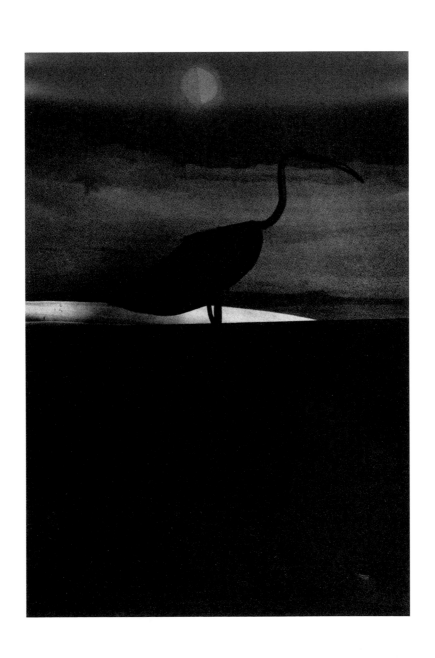

FOREVER AND EVER

You, dear Yolanda, have gifted me
with three things I treasure deeply:
 faith, passion and love.
Crowned with your heart, these blessings
come dreaming in, as though they sleep together—
especially when your skin caresses my skin,
especially when your lips touch my lips.
Our hours of togetherness arrive too slowly,
then quickly vanish like candles burning away.
Your long absences fail to discolor my heart.
Where, I wonder, do your thoughts take shelter
while swimming those lofty moments of ecstasy?

I imagine your thoughts as impassioned flowers,
sweetly entangled in voluptuous serenity.
Loving you so much nourishes a craving
to welcome your hushed footsteps at my door,
to embrace the light, glowing in your eyes.

Yes, dear Yolanda, your gifts should keep our love moving.
And we should forever say NO to any farewells.
I am happiest when I find myself in the dead center
of everywhere with you
 and
 only you
 at my side.

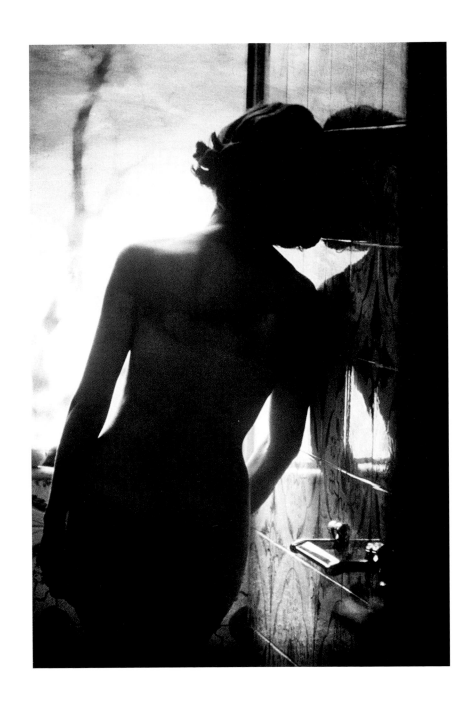

A GIFT

Just above her unfaithful lover,
a wild bird winged over the wasteland,
while below a deserted rose was
slowly dying on the perilous rocks.
The flower, a gift for her,
had been sent by him from Hell—
his luxurious cove of betrayal.
Ferociously, she had flung it
to the death the flower deserved.
Then, like a discarded memory,
and without the coldest kiss,
she was gone, forever gone,
to find refuge in the sad light of autumn.

What was once their realm of Eden
had crumbled into a passionless ice land.
Now, no female gave shape to shapeless nights—
or flew beside him through the endless woods.
No ardent heart beat beside his heart.
Where, he wondered, was she hiding?
By now her silence was outstripping the wind.

She could have told him everything.
Her eyes had no intention of being deceived.
Now, her nest is taken over by another lover.
And joyfully she holds the same rose Satan had sent.
But no longer were its petals crushed between rock and wind.
They could now bloom—
 in the sweet light of forgetfulness.

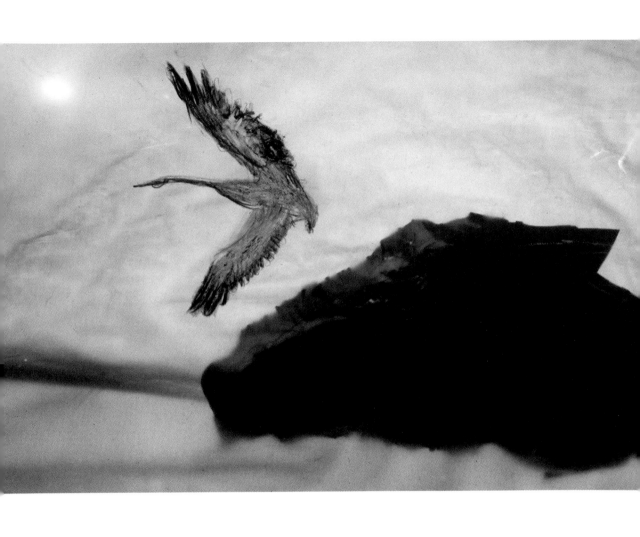

PROBLEMS IN PARADISE

After wading through hours of lonely nightfalls by the sea,
I was ready at last to blend Mathilda's passion with mine.
But seconds before our bodies met, a sheet of darkness fell
 between us.
Her eyes, after combing the walls,
were ablaze with
 wanting,
 doubt
 and terror.
Rusted stars splashed into the bewildered sea,
and gray doves slithered through angry brine.
A flaming wind blew in, accusing me of
something I had willfully misunderstood.

"You know, OLD BOY, she is only half your age."
Such thoughts were like rock salt to me,
smothering my intentions with confusion.

"Not now, Mathilda! . . . Some other time! . . . Some other
place! . . . Some other . . . ! Some other . . . ! Later! Later!"

The bells of righteousness sounded, screaming
from my childhood nourished with honey and care.
No doubt, what my appetite wanted for supper held
a kinship to forbidden fruit. After thinking it over
I lied and declared: "My cupboard is hopelessly bare!"

Thankfully, that perceptive wind blew in,
shaming me and rescuing her from a blinding fire.
Having put my illuminated past to good use,
I could lie down now with safer endeavors—
while carefully avoiding yet another Mathilda
who might happen to make her bed
in some love-splashed house, down by the sea.

Why, I often wonder, is this
so deeply held in my memory?
Just the other day, as I walked slowly toward nowhere,
 the recurring story stopped me.
With nostalgic fingers, pointed toward the sea,
time flowed back. Then, within the drop of a moment—
 it was gone—a bad dream gone.

AROMAS FROM THE PAST

Often, into the deeper shadows of yesterday,
his memories drift back to smell those roots
that had failed to branch from promises.
Some places where he expected rosy memories to be waiting,
clusters of sharp needles waited instead.

At times, the prick of those terrible spikes
turned out to be valuable gifts from the earth.
 Like friendly swords,
they forced him to cross the most turbulent rivers.
And though his hands were wounded by their sharpness,
his ears were deafened to their cold threats.
Yet his bare feet survived the heat and snow.

Today he remembers so much
those sharp needles forbid him to forget—
like rivers full of cloudy waters,
and calloused hearts of racist stone.

So often barrels full of needling memories
come search for him in his dreams, his closets, his car,
the subways,
 bars,
 churches,
 ghettos,

 and everywhere.

Yet now, without holding his breath, he can laugh at their aroma.

DAPHNE

Time and again Daphne asked me to come over.
When I did, she hardly remembered who I was.
By now I'd become another stranger.
After withholding her secretive problems,

 she smiled,

 handed me my hat

 and showed me the door.

A full moon hung in the sky
when Daphne married Jasper.
When time came for them to do
what newlyweds do,
she spread a quilt for him

 on the floor,

took to her bed and reread
a pamphlet for the "disturbed"
she had retrieved from the trash can.

Jasper awoke at dawn to find her gone.
A note (via toilet tissue)
explained the absence.
"I'm off to Tulsa to be born again.
Sorry. See you on Good Friday."

 > > >

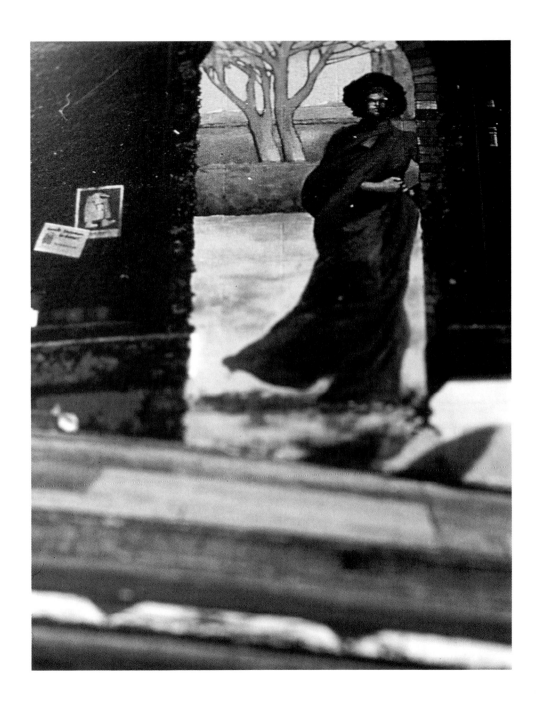

Something went wrong, terribly wrong.
She landed in Kansas City instead!
Viciously, she accused her ticket of lying.
But it defended itself nobly.
Nothing disputed its claims.

 Bewilderment! Frustration!
 Falling in chunks! Big chunks!

Hostile self-pity began overflowing!
A devil had grabbed her tongue!
Daphne wasn't herself anymore!
Anger sped her to the bus station,
where, with an iron voice,
she demanded a free ticket
to the Hell of Afghanistan.
Bafflement devoured her completely.
A straitjacket was summoned—
to haul her to labyrinths for mental repair.

After many spattered moons, she emerged.
While Jasper's hopes rose, mine quivered.
I wondered why her soul chose to dress
 in torment instead of joy.
No doubt, while she danced in Heaven and Hell,
they had become one inside her.

To her everything smelled of a decaying world.
Like a hawk she winged on and on—
 soaring, soaring through
the thunder of earth's savage storms.
The devoted soul-fixers stayed busy:
 Reshaping her geography
 Scratching out the darkness
 Razoring away despair.

Cured now, Daphne sings praises to her healer's care,
with songs of valor to their thankful ears.
And, with a freedom granted to pardoned convicts,
her clear mind, soul, hair and bones,
gallop upward,
 to the tranquillity of smiling skies.

TICKET TO HOPESTOWN!

In my wildest dream, and one not to be hidden
 by time, or pillows,
Sam Jones, a staunch white buddy of mine,
decided to fully express himself.
 Now, believe it or not,
he painted his skin a bright red, white and blue,
then proudly draped himself in a star-spangled flag!
(At least that's what my dream was showing me.)

The vodka we had shared outside Jimmy Crow's Tavern
was doing the dreaming—and the talking as well.
In any case, we now scaled a rugged hillside,
and, to a curious crowd, Sam was hawking tickets
to places I'd never seen, or heard of,
like—Hopestown,
 Gunsgrove,
 Whitestown and
 Lynchvale.
What a dream! According to Sammy, these towns were close by—
all waiting patiently in our Southland State of Nowhere!
What's more, all were easy to get to!

Sam had lots of takers—all dressed in colors of a rainbow.
After giving it some thought, I became one of them!
With a ticket in my ragged black pants, I was off—
stumbling down a grimy hillside toward Hopestown.
Sam, I soon found out, had not only misled himself—
 he had misled me!
The one place of promise he named, spit on me!
Streets and sidewalks croaked like angry frogs!
Hatred littered every dawn!

The entire town's eyes were those of nasty barbs.
Even the wind seemed to be mad at my presence.
 No doubt about it!
Sam's Hopestown was still far, far away—
hidden by ravaging storms!

Someday I'd love to forget that vodka dream.
But like a tangled weed, it keeps turning up again and again,
 to haunt my memory.

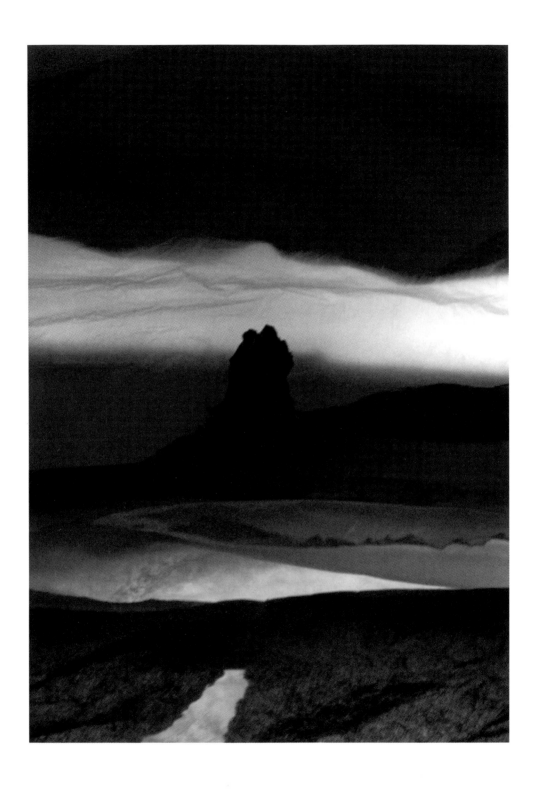

WRATHFUL FRIENDS

She and he, with doubtful hearts,
had stuffed themselves into my existence
to help conquer my worrisome loneliness.

Why do they cling to my memory like worn-out shoes?
Both entered my door, uncorked my finest wine,
devoured all my food and prowled through my privacy.

Two meddlesome friends had just dropped in
 to cart off my loneliness.

They were still with me at daybreak,
peacefully snoring on my favorite pillows.
Having drowned me with moments to be forgotten,
 they finally left,
after polishing off a bottle of my best champagne.

Morning had come to attack my bones with weariness.
I reclaimed my pillows and sank into their warmth.
When that stubborn loneliness goes to work again,
I splash it with memories of four worn shoes.

And instantly I am saved.

HORATIO AND REBECCA

Both, I'm told, still cherish some love for one another.
Perhaps she was wrong
about things that got in their way:
the too-tight dresses she wore, his grunting
that pounded her ears night and day,
 or maybe
those awful movies she picked to fill their troubled days.
Perhaps Horatio, blind to his wrongs,
stayed too busy with his old junkie ways.
So, after three years they—
 a once-honeyed pair—
found themselves wed to a ruinous crack pad,
and bound by a ghetto's despair.

But an ancient warning bell, hiding in their mind's belfry,
offered a prophecy from a timeless past:
"Listen well, you lovers. Tomorrow will contradict yesterday.
If you consume the golden dawn today . . . today . . . beware.
 Tomorrow could arrive too late!"

Right then and there Rebecca and Horatio swore
never to give in to temptation.
 They even dreamt of it!

But tomorrow turned out to be Sunday.
And somewhere between sunup and moondown
Horatio and Rebecca, after far too much grog,
cut up their dreams with greedy knives and forks.

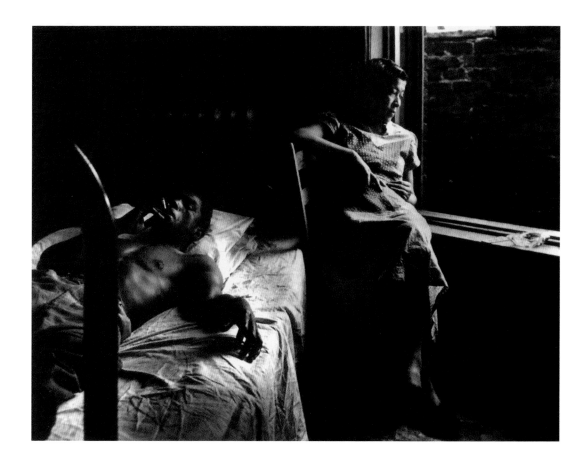

Who would have thought that a few swallows of grog
would alter dreams so quickly?
At dusk I saw them ambling toward their cave,
Not a word passed between them.
Obviously the warning voice from the belfry had died.
Their skies seemed to be gray
 with newborn clouds.
I last saw them descend into a subway's darkness.
Once they disappeared,
nothing was left but salt.

THE STRANGER

I first saw him, staring balefully at me
from behind a facade of scorched years.
 Now in the approaching clouds he stood,
gently rubbing the creases of an ancient leather bag.
Tired of patience, I stared back—hard.
During that aching moment truth struck.
With eyes glaring,
the stranger nudged me backward,
to the unfathomed and blighted past.

Deep inside his bag were dreams
that had roamed inside me for ninety years.
Some, wrapped in pain, arrived slowly.
Others, many others, refused to show up.
No longer do I worry about dreams unborn.
There is still time for them to arrive—
still time for them to start living.

Suddenly the clouds lifted and rolled away.
The moon came to life. The stranger was gone—
leaving me to ponder my shadowy world.
I had traveled through grief and sorrow.
Things were still not as they should be.
Multitudes of conflicts lay in wait,
and some unfulfilled dreams were around the corner.
The stranger is still out there—somewhere.
 Still watching.

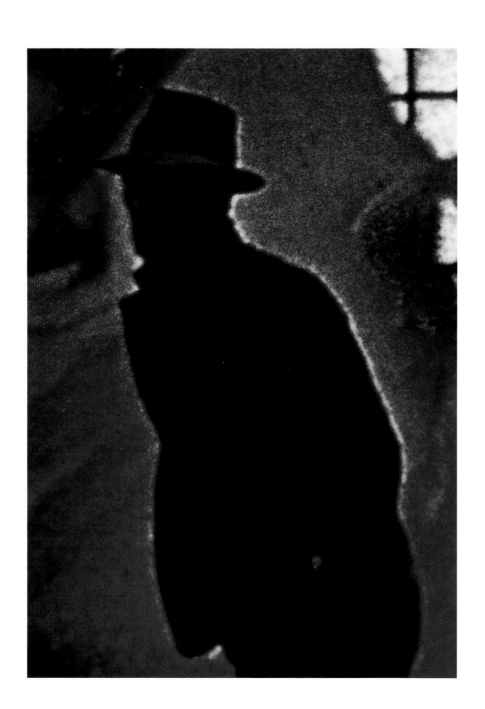

IN RETROSPECT

My memory is well filled with stale smoke
left over from mistakes I made.
While hunting down answers
to rescue myself from waves of darkness,
battering currents carried me farther
and farther from the shore of felicity.
My eyes, witness to the bedlam I swam in,
saw one hope after another wilting
before they earned the right to bloom.
Vulnerable and still wet, my ears
grew plugged to horned voices, howling
from mouths toothed with jagged glass.

If then, the right answers were found,
then plied with my left-handed questions,
I would have been accused of swimming backward.
Come to think of it, my most searching inquiry
would have had the color of diluted water.

Perhaps I was luckier than most.
My eyes and ears seldom slept.
Ensnared in the web of innocence and confusion,
they could find no time to sleep.
Restlessly devoted to futility, my eyes and ears went on,
looking, listening, while my nose snorted the smokiest dreams.

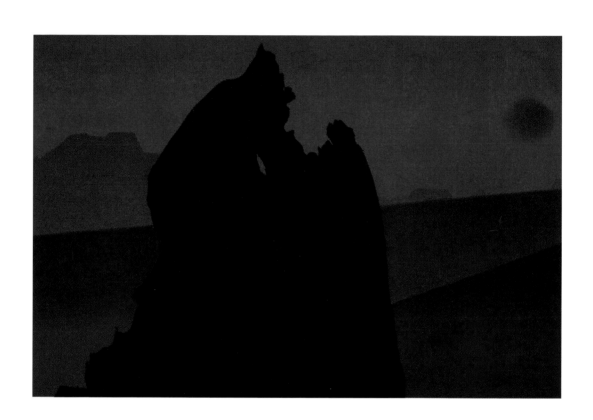

DREAMS AND STORMS

Late for appointments, Dawn was upset.
Because Day was nearly an hour late.
"Stop worrying. You've no place to go," Day said.
Infuriated, Dawn snatched a map from her pocket,
then pointed to Africa, Italy, France and Spain.
"Are all those places no places?"
"Ah, cut it out. Night has to get there before we do," Day said.
Somewhere in the darkness, Night was hiding—
refusing to be caught up in the confusion.

Suddenly, an angry storm came roaring in.
Skies burst into flames.
The sun melted.
Trees sobbed.
The earth rumbled.
Hell vomited wrath over frightening Day,
churning the entire universe in a vicious wake—
when my alarm clock yelled for me to get up!

It had all been a nightmare—a weird, disjointed dream
that recalled another violent storm—
one that nearly brought me down, before deciding to die.
Should you want to hear more, have a talk with my memory.
 Then, try sleeping soundly through the night.

NO APOLOGIES

Fate holds no reasons to frown
at what Providence granted me.
My thanks remain uncountable.
After long talks with my past
I now realize that life held a divine purpose,
for shoving me into places
that were as changeable as the wind.
In between the floundering of then and now,
the eyes of fate were following me—watching,
always watching with narrowing glances.
Now, having given deep thought to life's offerings,
I realize that everything that happened
 should have happened.

So my heart lifts praise to a smiling autumn—
To those fallen years that no longer exist.
With this, and with no respite, I give thanks—
to each dawn,
to each night,
to all the falling
and climbing
that patiently carried me
through unpredictable wanderings.

Crowned in the confusion that hammered my journey,
One golden thing stood:
 Love—serene love.
Nothing could banish love from my wilderness.

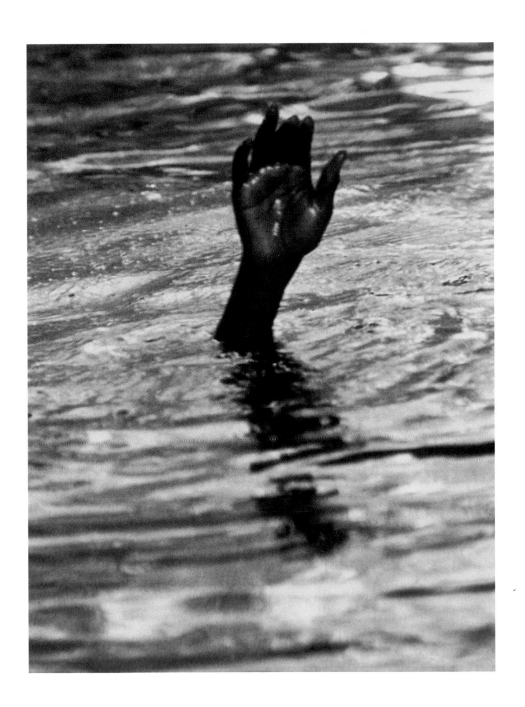

NIGHTMARES

Like dew they come sneaking in.
And lost in their meaning I follow them
not knowing from where they have come,
where they are headed, how far they are going,
or if, like a flame, they will sputter and die.
At times they disappear in a fog.
Then, with the speed of a gazelle,
 I follow.
By now I should know how to escape their clutches,
but during some counterfeit moments
another comes riding the wind.
My problem is simple:
I can't seem to meet dawn without obsession,
without a skyful of things
galloping inside me like wild horses.
At times nobler figments take note,
flame into my liking, and wait to greet me—
at some mysterious landscape
or wherever they happened to be going—
usually some unforeseen place, drifting in silence.

No doubt, the nightmares will keep coming,
strangely mixed with music, clouds and stone.
By now I should have learned to expect them.
But learning rides a painfully slow train.

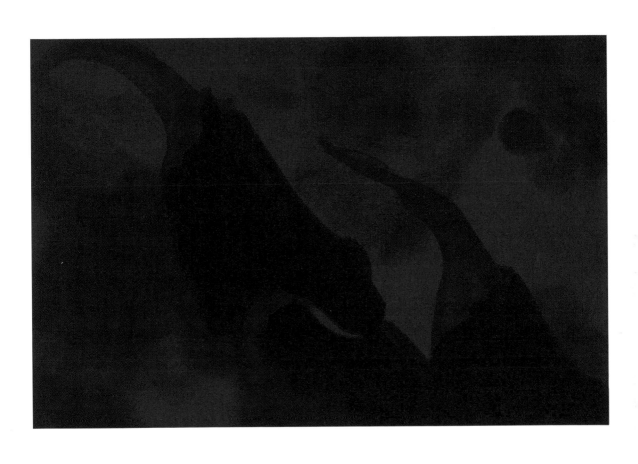

SHADOWS

ghostly

grim

baleful

disturbing

monstrous

brooding

all clutch us from time to time.

But there are luminous others—

whispering

flickering

peacefully swimming in dappled twilight.

While honoring our destiny, all fall asleep—

 now and then.

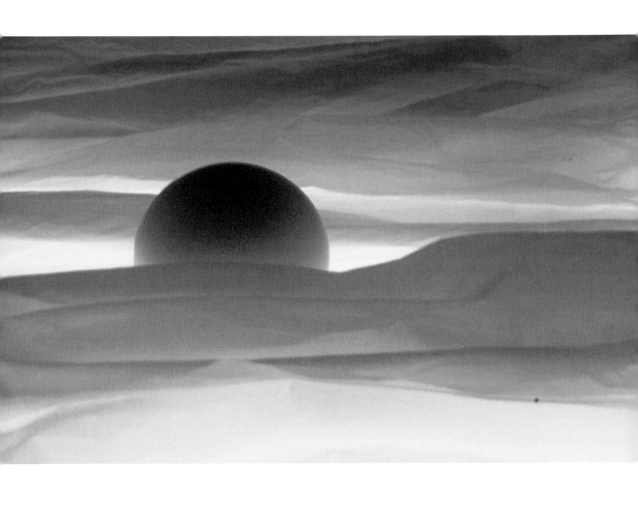

IT HAPPENED

Up I was going!

and

up

up

when suddenly

down

down

down I dropped!

Honey and salt, born enemies, were now my foes.

The passions they devoured were defining them.

By sharing bread with both, I had exiled their patience.

Now, they left me alone to suffer their silence.

Like a bewildered bird, I had disappeared

behind a wall of darkness,

where petals of ill will fell like rocks.

Hell offered me its blistering heart—

and promised to stay with me forever.

Gentle winds no longer knew me.

And there was hardly a storm that ignored me.

Wisely, I decided to have a long talk with

what was left of my good common sense.

You can't get along with both, Pedro.

It's either—salt or honey.

Just remember the sweet treasures of spring.

To such advice I should never stop listening—

even on the worst shadowed night.

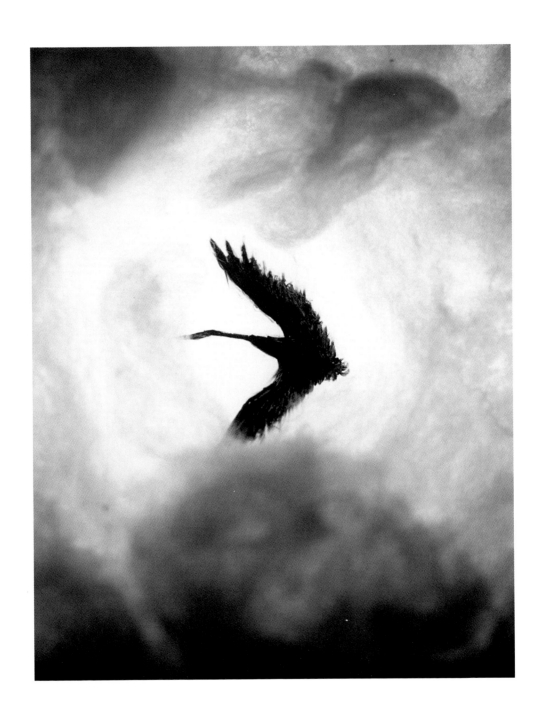

THAT'S THE WAY THINGS ARE

Recently my memory is slippery, like an eel.
The spectacles that were missing this morning
were kind enough to turn up on my head.
Then there was this stupid pipe.
I'm sure I left it in the bedroom last night.
But after an hour's search this afternoon
I found it, waiting patiently in the den.

When I arrived for an affair a day late,
my calendar was officially held as the culprit.
Truthfully I forgot to consult its pages.
At the moment, half a banana is hiding.
I'm dead sure I didn't polish it off—dead sure.
It's as though I'm hunting for a forgotten name.

Believe it or not, I've just found it—
rotting away on the bathroom shelf.
I scooped it up, hurled it into the john
to watch it swirl around a couple of times
before flushing into that well of nothingness.

Funny, things I forget are often more significant
than things I remember. Well, have to get some sleep.
Someone or other is arriving early tomorrow morning.
His name escapes me. But that's just the way things are.

CONFESSION

To some, Time has been stingy and unreasonable.
 To me,
it has been generous, and despite the prickly paths
and rocky horizons, I somehow kept going and going.
Now I can kiss Time's sweet mouth for saving me on
those days I am waiting for what the next dawn offers.
Often misery fills my heart with stones.
But never forgotten are the joys that wait:
brand-new skies with golden stars, sprinkling the night.

No longer do I ask Time questions.
Nor does it bother to ask me where I am going.
Time has already shown me what everything is about.
When doors I never expected to, suddenly opened,
I held my breath and entered. Inside there were
unanswerable questions that I wasn't expecting.

Hurrying to please myself, I went back to my old habit of
forgetting things I found unworthy of remembering.
The lingering questions went unanswered. I had knocked.
Someone had been shrewd enough to open the door!
Now, thanks to Time, my smiles are far different smiles.
At long last! Understanding—in both the meat and the stone!
With Time on my side I've good reason to keep swimming
life's roughest seas, while bathing in its broiling flames.
And through it all my ancient skin will remain the same—
 BLACK!

A DREAM

Frowning, a phantom shook the night with fury,
until dawn moved in to conquer its rage.
Then corollas of morning declared themselves,
and, like a thicket of flowering lips,
kissed the brand-new tomorrow.

Until then months full of sour yesterdays
had been consumed by things out to kill.
Bitterness had pierced my hopes.
Providence's work had been fulfilled.
Such disturbing nightmares
often take aim at all of us.

These things, and more,
are what God expects us to endure—
 life
 trial
 error
 success—
 and finally, death.
So remember, and keep on remembering,
that ancient things on this wheeling planet
won't change during some irksome night.
What fell hard yesterday can rise gently tomorrow.

Often our daily bread is baked with hell's baleful fire.
Thankfully, its crust is not always fluted with brittle.

AFTER MOONFALLS

Not until recently
have I discovered the significance
of full-blown moons.
Nor have sapphire stars
ever spoken so truthfully to my heart.
No, not until I found you waiting
in the spillways of their essence,
did I no longer ignore their presence.
Before, the luminous orbs
took refuge in hidden places,
denying me the dawn in your hair,
the passionate rituals of embraces.

But during our many and laureled pleasures,
your lips have breathed heaven into mine.
Up there in the sky's silent space
both moon and stars are always smiling.
To them I owe the thrill
of touching my lips to your lips;
the velvet dwelling in your caress;
and the violent waves of love
that fall upon us like flaming lava.

Now, dear one, I find good reason
to gaze into night's labyrinth—
knowing that up there, moons and stars
can light the pathways to contentment.
Their stellar purpose, no doubt, since the beginning.

ECHO FROM THE DARKNESS

Sleep had fled to the edge of the world.
Dawn was still miles away when,
 to my consternation,
a wave of unrest pulled me upright.
My tobacco pouch was hiding somewhere, smiling.
And my empty pipe was smoking fury.
Immense desperation was rolling in—
deep into my shoulders, stomach and knees,
searching the sleepless night for my soul.
While fighting fatigue's dark touch,
my eyes dropped to the floor.
There a book lay—unread.
Aware of my dilemma and filled with solemnity,
Richard Wright watched me from its cover.
Gravely, he was telling me two things:
only roseate dawn can murder the darkness.
Yesterday can show tomorrow the right way to go.

Brooding images suddenly appeared.
Richard's advice, sound as a rock,
was not to be invoked in vain.
Memories piled upon memories.
Daylight was growing. Time was in a hurry—
falling away like drops from a rainstorm.
Then a memory flowered.
 Mind-jumping, to Paris I went,
where together Richard and I walked along the river Seine,
free of down-home racism,
 lynchtrees,
 and White Only signs.

Page after page of his blighted past met my eyes.
And, before the curtain dropped, he had said it all:
"No one taught me. I learned by walking life's bloody road.
And at times I paid dearly to learn just a little.
I tried building bridges of words between me
and the world outside. It's been that way for a long time.
Foreign wars! Racial wars! All the same!
Those to come will keep on destroying humanity.
America must find a human path for all of us—
or Black and White will go down the same drain."

Dawn was still headed toward my window
as Richard shed light on his passionate intentions.
"I'll be hurling words into the darkness
and wait for an echo. If one sounds,
 no matter how faintly,
I'll be sending other words to create a sense of hunger."
Morning entered—wrinkled into a rusted rainbow.
So many times Richard's words burst into golden echoes—
 only to be riddled by carping tongues.
No longer did my weary body crave sleep.
He had appeased the cry of its meager hunger.
His turbulent past had tempered mine.
Before long the room trembled from my snoring.

CONFUSION

It's time at last to look back,
into the vanished years,
into the tangled moments
that fed roots that bloomed
 into a better today.

Trembling like leaves in a storm,
memories come—biting at times,
soothing at times, as they travel
the forest of my shadowy past.
I can only swallow the stalks
of the choices I made
in this vast pavilion of ashes and fruit.
Floating beneath bright suns and murky skies,
I'm left to ponder the sweet and bitter taste
of what happened between then and now.

At times fragrant flowers adorn my dreams.
But when nightmares arrive dripping with blood,
confusion covers the flower petals with torment.
Last night's moon and stars were floating together,
when, like a bolt of lightning, my anger flamed, my
peace exploded. Downward roared a fiery sky,
 and my contentment galloped away.

> > >

Lately my confusion rises and falls like a hapless cloud.
But without it there would be nothing to question—
no ups, no downs, nor human rituals to be accounted.
So I'm committed to confusion with a thankful heart!

Yet opening my heart to bumpy roads
hasn't made them any easier to walk.
A troublesome thought to remember, perhaps,
but one that throbs inside me:
the need to murder life's obstacles—
especially those that surprise.
Rivers of dreadful emotions have poured out
as claws of trouble attacked my peace.
Yet, by ignoring their intentions, I
showed contempt for the most lethal weapon: fear.
I've refused to walk with fear through its wastelands,
and hurled fear's savaging ways into the sea.

By doing that, I bask in the universal light of the world.
But somewhere in the dark wilderness
something nameless offers a threatening hand.
　　　　　　　　Does that something belong to me?
Sometimes comprehension hides itself
in the chaotic jungle of misunderstanding.
Confusion is left to placate my solitude.
I search the past for the final word.
Its voice will reign over the wilderness.

SUGGESTIONS

Yesterday should have a long talk with tomorrow—
about war-torn villages and battered towns,
about human bones stacked in holocaust ovens,
about graveyards without bodies or headstones.
Yesterday is no stranger to the leftover ashes.
It knows the dangers of wandering backward.
During some quiet and voluptuous moment
it could pull tomorrow's coattail
and point it in the right direction.

But today contradicts the past,
and can't help but condone the handwriting
that shapes the flowers, thorns and stones of our future.
How strange it would be to kneel down in prayer
with those who have never prayed our way before—
to eat from foreign platters, accepting exotic foods
our lips never bothered to touch or taste before.

Should such things happen, universal hostility
might yield to the justice of just praying and eating.
 together.
Today was bloody, so the newspeople tell us.
Tomorrow, they say, has cause to be bloodier.
Dead American heroes demand American retaliation.
Perhaps the past and future will eventually have that talk.
 Who knows? Who knows?

At the moment the defiled years seem terribly busy—
teaching young people how to kill, or die—
 with honor.

WHAT'S HAPPENING?

The lines are drawn. Some applaud the battle.
Others find it hard to digest its justice.
The differences have taken root.
Almighty weapons failed to show up.
Guns like to be kept busy. Without warriors they are useless.
Wars without victory amount to nothing.
Patriotic generals are expected to endure the fire.
Stuck in the mire of a brutal war, young heroes
are eating flames and breathing smoke.

Like bewildered newborns, they take refuge
in the darkness of the enemy's innermost places.
Our infantry appears to be lost on dismal streets
walking in the worn-down light.
Why are they patrolling bullet-pocked streets?
The inviting parks are now treeless and dead.
The riddled walls are rotting reminders of the encounter.
How long will our heroic sons wear warriors' boots?
Questions arrive with buckets full of others.
"Is your attic collecting dust and dirty rags?"
"Mr. President, is your attic overrun with complaints?"
Some distraught mother is bound to ask,

> > >

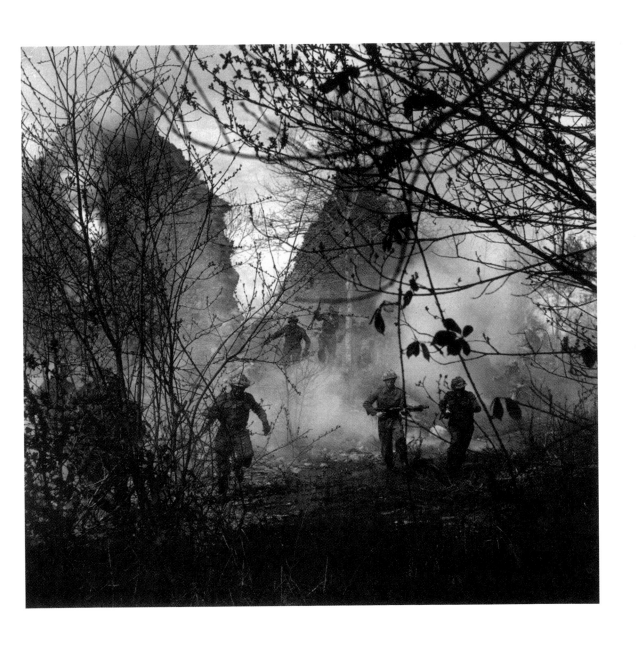

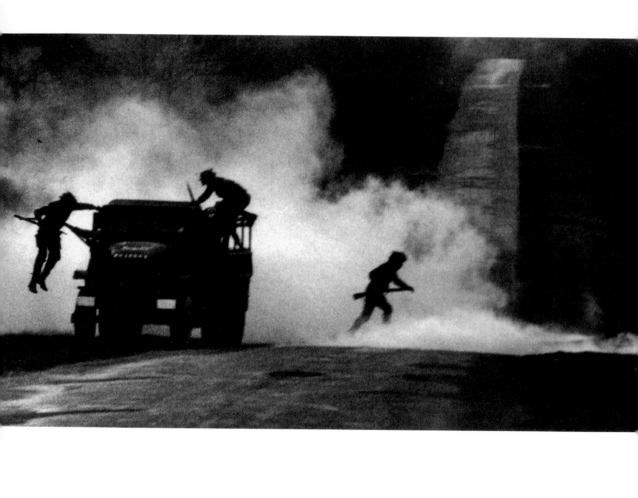

"What's my son doing there?"
Those questions will be spoken again and again.
Questions
enough to fill the White House.

Suicidal countries bathe in blood, their own and of others.
The gods of war promise nothing, demand everything.
All the while our president earns a degree in complexity.
We bow to our pride and we must learn quickly,
otherwise disaster may soon greet us.
We might have time to talk with our shadow
and share blame for the murder of peace.
But then, like a solitary thorn, you could be left alone.

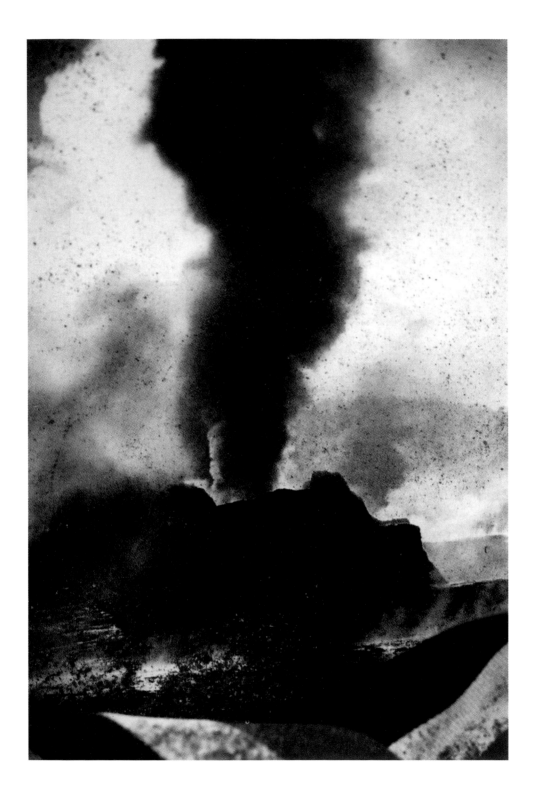

DEATH IN BATTLE!

All four were good mortals
with mouths, hands and eyes.
Hanging now, torn, bloodied
and brutally exiled from all feeling.
They could finally be left in peace,
to lie in the flames of their own flag.

Their murderers had, with enthusiasm,
dragged their corpses through the streets.
Like vampires, inhaling venomous smoke,
the killers stuffed themselves with fire.

Time will remember the path their hatred took.
Those left to grieve over blood-covered stones
will remember as well,
and those memories will
twist into rocket-propelled grenades,
while their lips mumble anger—
the kind that flows from broken hearts.

Before long those who grieve
will cry for the blood
 of their enemy's children.
The sun and the stars will rain down!
Claps of thunder will shake their world.
Disaster will find a new place.
The conqueror will lift another flag.

And death will just look on,
at mortals' folly.

WHERE WERE GOD'S ANGELS?

Hatred is scaling the heights.
Its ugliness leapt into Russia,
growled, looked things over, then quickly
prepared its cruel geometry.
Sympathy fled. Death was ordered
to spit terror into the frightened morning.
Waves of fire plummeted upward.
The flesh, bone and hair that was devoured
belonged to the honey of youthful chastity.
Grinning, hatred had come full circle.
No child could escape such wrath.

The universe looked, listened and quivered.
Where were the angels born to protect the children?
Their absence struck, stunned and awed the world.
Silence appeared to be the wine of their existence.
Could it be that shame expressed their absence?
Surely they were somewhere looking on—
But with speechless lips and wordless eyes.

For ages the bitter truth has come and gone.
The rocks of evil demand a place on our shoulders.
And it's hard to keep an eye on the spasms of living.
Whether they arrive at night, or during the day,
our problems will be those confronting God's angels.
And those problems will always overflow the world.

NOW AND THEN

For some reason or another,
our universe crackles with the wrath of terror.
Solitude, inhaling the fire, shoots upward
to churn into the chaotic tempest of thunder.

By moonfall the wastelands weep blood.
And blood, stripped of solitude, turns black.
Your forefathers knew this. Their fathers knew.
Now, like a seed sown from their troubled past,
 you doubtless know.

So, you ask, what's left for the likes of me to do?
My answer is pure. Your heart, like a hummingbird,
can sing with wisdom and the hardness of a rock.
 So listen carefully.
Tie your heart to the wind and let it blow
into the caves, castles and houses of hostile warriors.
Like a dagger in the air, your heart can track the culprits down,
strip them naked and dress them in your peaceful clothes.

Life, as God intended, can be wide and infinitely pure.
In the interminable darkness of war life can leave us
securely trapped in accursed acres of countless hells.
Your silence only adds stability to the ruinous walls—
to towers of infamy and death. So stretch your voice out
like an angry hook to destroy all those bouquets of evil.

BREAKING NEWS

Forty killed in Basra today! Small children blown apart!

Parents mourn students killed at Columbine!

Murderer gets life for slaying ten victims!

105 U.S. soldiers killed so far in war zones.

Over 1,000 dead in Korean train explosion!

 (MUSIC COMMERCIAL)

Once I knew a little bluebird,

and her wings were tinted gold—

she flew into a ballroom

and perched on a gay paper moon.

Just below were lovers dancing,

happy, carefree and so gay—

The scene was quite entrancing,

so the bluebird decided to stay.

Also high on the list of its calling cards:

Drugs for kidneys and livers and thugs.

Cars for speed—and just for women.

Cages for forsaken cats and dogs.

Problems for environmentalists.

Rights for gays and lesbians.

And, of course, the Dow Jones averages!

All these, and scores of others,

push into our minds,

marking it with scars.

WHAT NOW?

Ahmed Yassin, Palestine's murderer in charge of death,
had served his patriots with their highest purpose:
 to kill and keep on killing!
Now, at last, it was time for him to depart.
Fiercely, a couple of Israel's missiles saw to that.
They had, with their own bloody vengeance,
 slashed into his ancient flesh
and willed it to the shrouded kingdom of ghosts.
And there in aggressive silence, he sleeps in turmoil.
Within moments streets were crammed with heroes.
Houses of Yassin's enemies were catching fire.
The wind was screaming, filling with bombs and smoke.

What small hope that had been rolling inward
was suddenly running backward and frowning.
Buried in the gloom of Yassin's bulging darkness,
peace was still hiding beyond his morbid silence—
waiting impatiently for worlds of golden space,
to destroy their hatred and begin rejoicing again.
Of all meaningful things beyond the violent salt,
love is by far the most inexhaustible.
And within the realms of Heaven, or Hell,
it should have no fear of light or darkness.

So, in God's universe of unquenchable light,
there should be no doorless churches—
nor houses to burn in suicidal fire.

Though for years it has been brutally ignored,
peace still wanders Palestine's conflicting shores,
searching for some notable bloodthirsty desire
to strike conflict from its notebooks—forever.
Having survived so many centuries of bestial fire,
one assumes that Mideastern skin consists of stone.

But the fire of war, when aged with density,
 can melt the hardest rock.

At the moment blackening flames of anger
belch from torches of thunderous revolt.
Even stars must be terrified by the tremor.
Like an ancient martyr murdered,
Ahmed Yassin's absence will be flowing
with rivers of wrath and bubbling with blood.

HARAM! HARAM! HARAM!

During those same merciless moments
when four mangled corpses were
burning and being torn apart in Falluja,

Haram (the Arabic word for forbidden),
prayers were touching the blue-domed mosques.
There, in Islam, where the human body is sacred,
to desecrate one is to commit the gravest sin.

So for Haram's sake, and none other, Arabia's clerics
voiced apologetic confusion. That macabre celebration
that took place afterward was throbbing but unacceptable.

Long ago the cries of worshippers filled the mosques of Falluja.
The assassinations were heroic.
But Haram frowns at burning torsos strung from bridges!

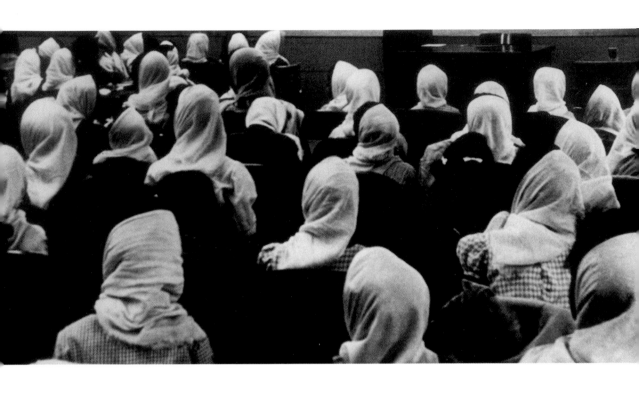

CHRISTMAS EVE TO REMEMBER

Terribly quiet was Bethlehem that night.
Death clouds hovered. Blood was in the air
where the Prince of Peace was born.
The euphoria, reckoned by that fallen wall
between East and West, was gone by now
after the dawning of a world's worth of hope.
 Bethlehem's Star trembled.
Jerusalem's sacred sand was about to turn red.
Trapped in the cadence of a star-spangled past,
peace carefully distanced itself from this night.

Abused by history, it was a hope departed;
a longing drowned out by iron hawks
rocketing above boy warriors in charge of murder—
who, with thin bravado, hid the fear of death.

I will do my best to bring you home without a shot fired.
And you will be welcomed, as you are All American Heroes.

The Commander's yuletide message from the White House
struck most ears as being vaunting and disordered.
(Without a single shot, ninety had already come home—dead.)

A ghostly past was watching, grinning, and knowing well
that within man's hostility toward man lies a forgetfulness
of young flesh blown apart under the banners of patriotism.
From the looks of things it appears that nobody on either side
bothered to remember. The massacre goes on, and on,
planting acres of underage bones to forever stare at us
from beneath crosses—without one ounce of forgiveness.
Another not so merry Christmas Eve is on its way.

Facing an enemy so solidly entrenched, the young warriors
will know some savaging twilights where death lies watching—
waiting to paint them a violent red with their own blood.

SADDAM

After a deathly search they found his excellency
hiding in a cesspool of fear, contrite, suspicious
and aging into the whiteness of overgrown whiskers.
His trigger finger, which was to have had the last say,
 had given up.

Without resistance, the gun dropped to his side.
Up from the shallow darkness, they yanked him—
to face places his brutality had reduced to dust.

Dare not to allow your thoughts to join his thoughts
or those thoughts that await him tomorrow morning.
His past, swathed in death, will be walking backward.
For him there remains no need for dreaming.
The blood he let can't wipe out his footprints.
Where once a tyrant walked, only a snake was left,
 condemned to live in a hole.

But one should remember, and keep remembering,
that many sweet dollars, flavoring his murderous reign,
had reached places where he was impatiently waiting.
And strangely they had been sent by the same captors
who opened a steel door and threw him into nowhere.
Now comes another colossal surprise.

Forty billion pesos, they say, lie beneath frowning sombreros—
in some places out there somewhere between the nowheres of
Moscow and Tokyo. They are also saying that they are his.
Who knows?

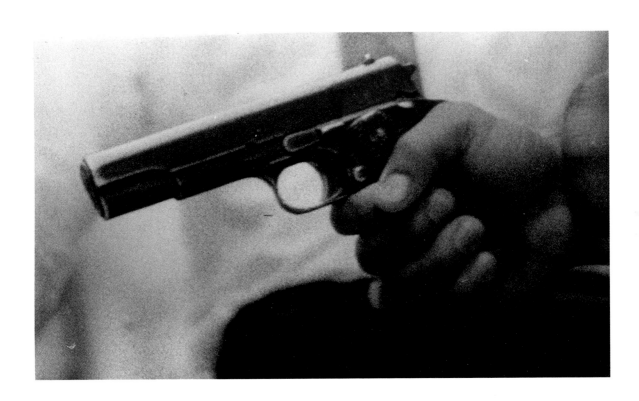

BOTTOMLESS TUESDAY

America—a wounded eagle—
shrieks revenge for a murderous attack.
Terror and anger race our shores together.
Our stalwart lady of liberty stands watchful,
scanning the horizon, awaiting storms
that are uncertain as the resting place
of a falling leaf.
Death clouds hover in blood-spattered skies.
Lionhearted rescuers search the rubble—
counting, grasping whatever was left—
an ear, a foot, a finger with a wedding band.
On and on they go, looking for signs of life.
Peace, trapped in the cadence of our star-spangled past,
distances itself from these battering days and nights.
Abused by history, a blurred hope departed.
Prepare for sustained assault! We are at War!
The Commander's battle cry from Camp David
burned with resolve and determination.

> > >

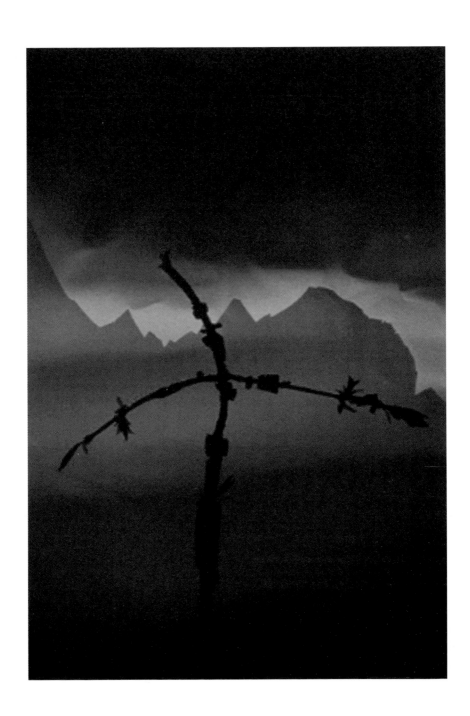

Consider the youthful warriors
before your diplomacy sees them dead.
Somebody on both sides listen!
Let us develop a preference for love
over that for missiles and poisoned air.
With fanatical design, the attackers
found chinks in our nation's armor.
Everywhere, in their dark world of holes,
 guns
are stealthily looking for them.
"We will find the terrorists before they strike!"
To those of us who remember,
this warning may seem reassuring.
Of those dead,
better not to expect any answers.

If I were able to speak with the dead,
to those who so nobly searched the rubble,
and vanished under smoke and flame,
I should tell them their feet walked
where few have walked before.

If, with their grieving ones left behind,

I could discuss the depth of their sorrow,

I would ask them to have faith

and hold it

with the arrival of every lonely night.

Ours is a planet with a multitude

of beliefs, languages and worshippers.

No one should desert our earth until they have found

what GOD put us here to do—LOVE!

Even death should not keep Love from growing!

SATANIC ADVICE

She finally said to him exactly
what the Devil had prompted her to say.
The night had grown quiet and cold.
The pillows had turned black.
The sheets, once a flowering pink,
wrinkled into drab nothingness.
Clouds, usually flowing with honey,
smothered the moon and hid the stars.
Slowly, painfully, dawn crept in
to find a love-bed shattered from pain.

It was all over? Her stubborn back said so.
 Well, maybe not.
Luckily, his heart had triumphed before.
Yet, more than once, he had failed
to recapture the joy of those earlier days—
 when her lips were his lips,
and their mouths flowered into one.
Perhaps what had fallen in darkness
might soar and flourish once again.

Hopefully, his fingers touched her shoulder,
which had grown ancient—colder than the night.
Having greeted his touch with ice,
she said what Satan told her.
 "It's over—all over."

An endless love had ended.

TSUNAMI! TSUNAMI!

The ghastly quake must be proud of itself.
It swirled angrily into Asia
and did what it came to do—
rupture the seas with armored fury,
flood the land with human blood.

Floating like rotten fish,
thousands of corpses sink in darkness
beneath the ocean's avenging waves.
Who, one wonders, placed them there—
 God, or the Devil?

It hardly matters.
Painfully, the tears keep flowing
into the curtain that mourning dropped.
A universal sorrow drapes the land.
 And, I'm afraid,
more misfortune will flash in the days ahead.
Despite their smell of age, tsunamis won't be weakened.
They must be proud of their longevity—
prouder still of the power they deliver.
With waves of catastrophic energy,
their fury rings with Destruction!

 > > >

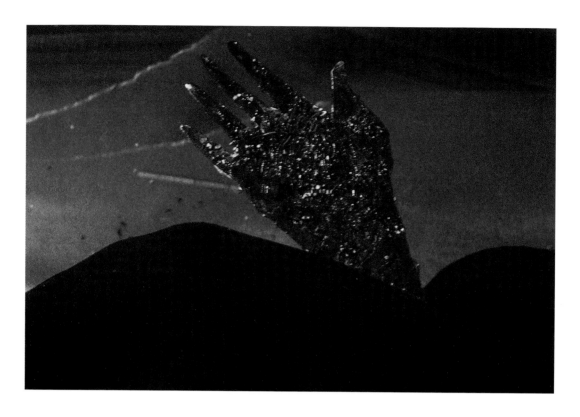

Hope? In the eyes of those fortunate to survive,
is almost invisible. Many eyes are closed to hope.
Death lurks, watching from the distance.
The mothering earth has spoken.
Towns are gone. Families are gone.
Human congestion with plagues may follow.
Volunteers build the waiting coffins.
Bulldozers push the unknown into graves.
Dead children are amongst them—
unless they meet bodies in stacks of fire.

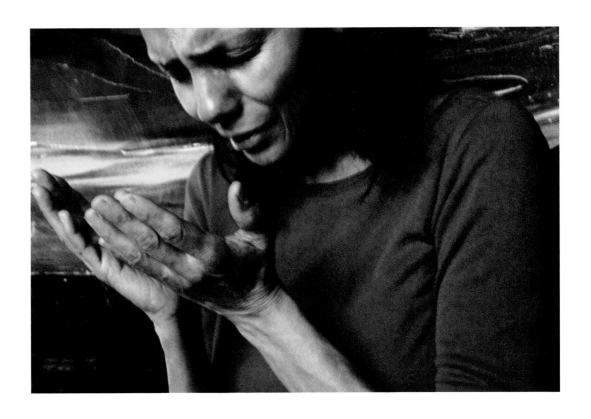

Time moves on. Nights and days move slowly.

Misery hangs on. Nothing, absolutely nothing,

will halt the tsunami's flowing, or take them out of time.

Old voices have lived too long to offer silence.

Asia's oceans and landfalls took on a brand-new look.

And in the course of things posed questions

that our learned planet is unable to solve.

LUNCH IN MOSUL

Today, twenty hungry young American warriors,
with a right to food, ate horrible death instead.
The suicidal cook, who quietly prepared the meal,
died with them.

And now with The Cook's ugly work fulfilled,
his living brothers smile at the menu.
They claim to understand his mission.
Surely he deserved their utmost respect
by giving himself to death, instead of life.

Meanwhile our politicians search the wind for answers.
They have a crazy habit of not knowing
what they failed to realize.

Deadly luncheons don't happen in the course of
 just another day.
And a murderer's uniform can easily change his skin.
Tell me, brother! What's going on?

Saddam is locked up.
Arafat is sleeping
in Heaven, or Hell.
Bin Laden's terrorists still hide in caves,
and fear of them is plump as a melon.

Nevertheless Bush still lives in that big White House.
The universe is existing close to nothing
though it's damn close to being everything.

My confusion is exhausting.
Pablo Neruda's words were well chosen.
"The world is asking leave to be born again."

Pablo is right.

COME SING WITH ME!

Despite the turmoil, anguish and despair
disrupting the planet we inherited,
there is something good I choose to sing about.
That something lies within us, patiently waiting—
 beneath us, above us and around us.

Its peaceful message yearns to fill
our places of murderous anger and hatred,
 to flourish forever.

Hope is the song I have chosen to sing—
a deathless song, flowing steadily beside my faith.
Whenever the fist of doubt knocks at my door,
it is powerfully turned away by my hopeful singing.
When things go from bad to worse I still sing my song.
 Why not?

It helps me endure the bloodthirsty days.
Once earth's fire had devoured my hopes.
As my twisted soul slid toward Hell,
Fate came racing from another direction.
Pinned to it was a belt of sun with new instructions.

These, it said, are for you! Suddenly Fear was gone.
I made peace with the mean roads I'd walked.
My jackals could now lie down in truce.
From that day on, I began singing the song called Hope.
 I still sing it loud—
above the waves, fire, darkness and mud.

TO MOURN — YET CELEBRATE

At last a voice was whispering—
"John Paul"
"John Paul"
"John Paul"
Silence. Scared silence.
His eyes and lips were shut—
to remain forever shut.
Attempts to awaken him
had been in the Lord's hands.
These arresting hands claimed him,
and welcomed him to the sylvan land,
but John Paul's soul was not dead.
Splashing suddenly into the mothering earth
it had sprouted into the hearts of multitudes.
Now, with tears streaming and contrite hearts,
some unabashedly asked to be born again.
Who might have thought that John Paul's passing
could have flooded hearts with such noble beating—
especially those with relatives who ate Russia's brutality,
or those whose kinfolk fueled Hitler's death ovens,
or worshipped a former Pope, who looked the other way,
when priests were accused of abusing children.
To some, these things are ancient memories of the past.
Suddenly the bad fruit seems to be changing its skin.
The man resting peacefully in a wooden box
 is now love to all things.
For the moment, at least, love, joy and tears
flow in the multitudes caressing the Vatican.
Their presence, I pray, will answer questions
their forefathers failed to answer.
He is gone and his purpose was fulfilled.
But there is still much more to be done.

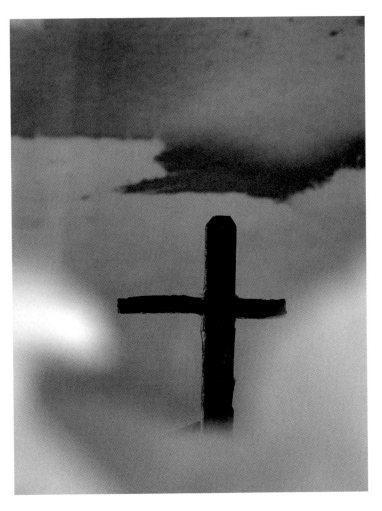

Hatred, bigotry and war are still around
despite his efforts to grant them death.
Remembering his arms stretched skyward
leads many to walk steadily in his footsteps,
Grieving by the multitude grew more fierce—
when John Paul's rugged cross interrupted
the immenseness of his beloved heaven.
Somewhere within that sacred vastness,
his soul has found a worthy place to rest.
And, adorned in the Lord's precious light,
he will remain there forever—and ever.

EPILOGUE

POPPA JACK'S LEGACY

Lucy
Ben
Louis
Percy
Mary

All belonged to Poppa and his first beloved.
Death claimed her somewhere a long way back.
It's decades later. Yet I don't know her name.
Strange, but no one bothered to inform me.
Poppa returned to the altar with Sarah. Then came
Anna
Clem
Andrew
Maggie Lee
Cora
Clarabelle
Leroy
Gladys
Lillian
 and finally
Me.

Having passed on, all seventeen are looking down, watching,
waiting for me to find his proper and final resting place.
A strange darkness fell over me last night.
So unexpected and yet so gently it dropped,
pushing aside a sleepless night in a way
that said my time was drawing to an end,

and that, without doubt, it was long overdue.
I was left to hope that I had served my time well,
that all those hours this planet had offered
were used in a way that won't be forgotten.
Surely against the odds I had done my best.
Looking back into the distance I see life's hardships,
the reasons for my saddest memories.

It would be untrue to say that I'm happy to look back.
Despite the time that God so graciously granted me,
I find myself wanting more, more, and more.
Call it greed, call it unreasonable if you wish.
Still for me, this darkness keeps gently moving in
 with proper notice.
I don't welcome it, but it's at the door waiting.
My best bib and tucker is hanging there as well—
 Waiting

Merci! Merci!

This poetry tumbled from events that besiege our existence. I didn't face the task alone. Others might question my way of expressing those ups and downs that confront our time upon this planet. Yet too many voices could introduce confusion. So I listened to only those whom my ears could trust. Hamilton Richardson spoke frankly and honestly. And as I wrote—he read. Malaika Adero's and Pia Lindstrom's tireless eyes spent hours scanning pages for clarity and meaning. Claire Yaffa, a sensitive photographer, was generous with soulful criticism. Eric Baker, the designer, joyfully transformed words and imagery into kinships. Johanna Fiore, a trusted assistant for sixteen years, served me nobly. I owe thanks and fine memories to each of them. And, I hope, they grasp the truth that prompts my deepest gratitude.